Tell Me How You Got Here

Also by Emily Franklin

Books for Adults

The Girls' Almanac: Linked Stories
Liner Notes: a Novel
Too Many Cooks: Kitchen Adventures with 4 kids,
1 Mom, 102 New Recipes

Before: Short Stories about Pregnancy from Our
Top Writers (editor)
How to Spell Chanukah: 18 Writers Celebrate 8 Nights
of Lights (editor)
It's a Wonderful Lie: 26 Truths about Life in Your Twenties (editor)

Books for Young Adults

Last Night at the Circle Cinema
Tessa Masterson Will Go to Prom
Jenna and Jonah's Fauxmance
The Half-Life of Planets
At Face Value
The Principles of Love, Books 1-7
Chalet Girl, Books 1-3
The Other Half of Me

Tell Me How You Got Here

Emily Franklin

Terrapin Books

Terrapin Books
4 Midvale Avenue
West Caldwell, NJ 07006

www.terrapinbooks.com

ISBN: 978-1-947896-33-8
Library of Congress Control Number: 2020939547

First Edition

Cover art: "African Grey Parrot Bird"
Vintage Image on Antique Stock
Artist Unknown

Here is the thing about a great teacher—and not just a good teacher, but a good teacher at the right time— they can change the trajectory of a life. One teacher changed mine.

This book is for James Francis Connolly

Contents

I

Japan, Autumn

Ikebana class one morning: arranging bulky kiku,
burnt orange kinmokusei, ume—Japanese apricots
eaten in winter. Nothing lasts, our teacher said.
She lived alone, side-street house with fusuma

instead of walls, sliding screens allowing her
to configure space for different occasions.
She criticized our arrangements, redid them
with a smile—kiku here, with space, ume there,

with space. Space—necessary and good.
Do you understand? Absence an object itself.
Hold onto space, she said, taking photographs
of our work that was really her work by then.

I cannot accept the space. I must accept the space.
You whispered, What does she mean by space?
Japanese architects deliberately inserted mistakes
into their designs to appease the gods,

who believed only they are perfect. We do this
with memory—forgetting, mottling as salve
for the soul. The sweet relief of broken memory.
In Tokyo, we argued in Ramen Alley about selfies

but really about your potholes of memory
dirt-crusted with skewed views, facts, names
of preschool kids swapped for movie stars.
Your brain famous for its limbic system—

hippocampus, amygdala, cingulate gyrus,
mammillary body, all diagramed years ago.
If not the brain, then at least decorative facts.
Those days in which you recited dates, ancient

Edo pottery, dynasties of information,
explained with sketches. Now forgotten. Or,
you held onto details we don't need now.
In Kyoto we walked along the canal

and tossed in handmade paper flowers
for luck, each one slipping, current-bound.
What to do? Hold onto washi fibers
from the gampi tree's bark or let go,

mitsumata shrub in the form of paper stars
now floating away. No matter.
You will pocket neither the paper
nor the word for it. Washi. Washi.

This is what we need: take only
what your hands can keep. Maybe that
is pain's definition: Only one person
retaining memory for two. How burdensome

being the architect, collecting flaws,
unable to sieve memories. Back at the canal
you do not wish for more washi stars.
This is my problem. Only the canal and I

remember, and even then, this water
only knows us as shadows. Both of us
leaning, willow bent, over what we've thrown.
Oh those flowers we recognize but cannot name.

Walking the Dog in Autumn, I Stop
to Tie My Shoelace

We do not understand trees—why certain ones
have turned already, apricot-edged, marmalade-bright
next to others still summered as though they've forgotten
or are immune. Are we allowed to write about trees
anymore? How easy it is to feel foolish looking at them,
when—right now— we are in the sweet spot.
Four children old enough to shower themselves,
the oldest permitted but not licensed, the youngest
with Jack O' Lantern teeth, the girl seconds away
from a bra, body as yet unloathed, and the middle boy
out of the hospital and able to tie his own shoes.
My parents, too, are young enough to shower themselves,
Dad in remission, Mother's fingers agile enough
to tie her laces. How wrong is it to wish stasis,
the irrational desire to have all of the selves—
past, present, future—overlap. To wish to make
a note so that tomorrow or two months from now
or when the disease returns, we have proof.
I am still someone's child. My children—
not mine, but of me—tethered, my marriage whole.
To be jam-stuck in this sweet spot would mean
never to see all four become however they will become,
would mean not spooning warm apricot preserves
into my father's mouth when he can no longer
command his own hand. I want both—this
and the becoming—smooth or bark-rippled,
all their skin soft as a pocket I will never understand.

My 8-year-old son

flips through *101 Cookie Recipes,*
the book he chose at the yard sale
where he asked to stop on the way back
from the hospital where he recovered
from his rape and where I had been
the week before, emerging with one kidney.
We are in our regular clothes,
sutures hidden in our sweats and t-shirts
as we pick through other people's lives—
pans, salad bowls ringed with old oil,
shoes missing laces, the full-color cookbook.
Mint layer bars or lemon ginger snaps,
twisted caramel peanut butter, dough heavy
with apples or toffee, dropped
by the spoonful or spread into pans.
He cannot decide which treat to make,
folds over nearly each page, corner after
corner bent, agonizing over what to want.
The recipes are caked in someone else's prints,
smears of icing and ancient chocolate stains
that to my son twitch alive on the page—
here, pick me, this one. Each unready cookie
fingertip-close, raw on the palm.
We huddle next to each other,
unsure of what has ever belonged to us.

We Bought the House

We bought the house
with its contents, a body complete
with lungs through which other
people breathed. A whole other family,
smaller than ours, and before that
lodgers with so few clothes
the closets only held one suit.
The pull-handle fridge housed
one gallon of milk, nothing else,
its halo of light illuminating
the plastic carton as if
the 2% were art or magic.

We moved into rooms
that were not ours—the couple
had withered here, in separate rooms,
drawers tufted with decades-old
cotton balls, wooden swabs,
pamphlets on diseases we didn't have,
every kind of screw and nail
jumbled with others of their kind,
segregated but mislabeled.
The boy—now mid-60s—
who'd sold us the place left pencil marks
and instructions: this screen
is for my room, this one Dad's.
In May—but not before—
swap the front door glass insert

for screens. There's a nice wind
at night that goes through the yard.

We let our son play with left-behind,
rusted trucks, even when the backhoe loader
snagged and split his toddler thumb.
Blood surprised him, came from inside
his body which maybe he had not
considered yet. He had not wondered
what was inside. As he dried the blood
with his striped all-in-one, he pried
a loose tile from the cold fireplace.
A note, folded: this is me,
this is my face, this is my house.

I moved seventeen times before
I was seventeen, but at the first house
we left this: a planted dogwood
for Mother's Day. Seven years,
our longest in any house, we waited
but never a bloom. The year after
we left, we drove by, saw pink and white buds
active as birds blushing as though
they were embarrassed for us.
Embarrassed to see that they had burst
and bloomed after we were gone.
Maybe something in the soil or maybe
the house was done with us.

From my grandparents' house
I took a brick. Did the new owners notice?
Had they, too, left or taken something
from their apartment or farm

or townhouse? And in our house,
this note from the boy-now-man
shucking the contents. You moved a tile
and found the folded paper as though
treasures like this just appear behind
or under things. You were an early reader.
Praised for this though like the blood,
it just appeared one day, your mouth
surprised by words you could read
on the moving boxes: This way up.
Fragile. Contents heavy. So you read
the words on the fireplace note
written by a boy who was now
an aging man who didn't want this house,
left us his parents' wedding china,
their silver, their hate-group mailings
and mechanic bills, a pile
of seasoned logs that would be perfect
for the fireplace if we ever fixed
the chimney liner. You could say
the note's words, your thumb bloodying
the sketched face, but you didn't
understand—I thought it was ours, not his.
Yes, I said, and then corrected myself:
it's both. At night there's a nice wind
that sweeps through our yard.

Grandfather Reappears

I dream you are back from the dead
and working at Walmart.
Even when visiting me posthumously,
you must keep busy, work off our debts.
You are a doorway greeter with your beard
and doctorate. Oh, your baggy forearms
and pumpernickel breath, estuary eyes
of mossy loss, jetties of medical methods.
This is the perfect job for me, you explain
in your blue polyester vest, nametag
pinned on your life-raft chest. Flow
of shoppers you direct this way, that.
Those features that held you back—
slow gait, poor hearing, iffy olfactory—
are of no matter now. You know
everyone's name. Have your own teeth.
Ring of hair, head gleaming in the filmy
eco-light. Hello, my name is Bill!
You wave those hands, topographical veins
I pulled and pressed, wedding band
still too small. The doors open, slide,
beckon close, slide, and open again
as you stand large as paper towel towers,
sturdy as boxes of Goldfish, bright as Windex
pyramids, those household talismans
welcoming us in. Come. Come see.
Come see everything we have to offer.

Biology on Goodhope Bay

We want to understand
the world, but now they've discovered fur seals
trying to have sex with penguins—
King penguins, who dine on lanternfish
and squid, suited for mourning
save for yolky patches on the ears, sunburst fading at the chest
laying or guarding pear-shaped eggs.
And now on Marion Island, home to both
Antarctic fur seals chasing, mounting, capturing penguins.
Part rough play, part predatory, and still another part
scientists describe as accidentally sexual,
as though even between species
this kind of thing just happens,
is not intentional.
Say it was summer, a desolate island.
Say it was just one time (discount the incidents on
 Funk Beach and Trypot).
It will not, experts agree,
happen again.

Flânerie

Around 1840 it was considered elegant to take a tortoise out
walking. This gives us an idea of the tempo of flânerie.
—Walter Benjamin

In the 1840s elegance was walking
your tortoise on a leash

My youngest had a pet ant
and then ate it by mistake

After their wedding reception
my parents found an ocelot

with a bow around her neck
which was not a metaphor

as my mother thought but
actually a gift from my uncle

whom it later tried to maul
(which is maybe the metaphor)

My husband heard this lore
and wondered where one

purchases such a gift as though
the world is hiding from him

Wild animal shops or places
ants are up for adoption

Just what leash would fit a tortoise?
When our friend's tortoise

ran away (slipped from flower
bed to God knows where)

our friends cried and my husband
laughed, then formed

a search party—sticks and lights
flickering in the summer woods

Two days later the neighbors
found their animal three streets away

and my husband, guilty
for his laughter, designed

a tortoise run—suction cup, wire
The stuff of comic books,

of futurist antiquities
The public elegance of

contained creatures.

As My Children Outgrow Our House,
I Consider Household Goods

What is the need to catalogue
every item in the house—to hold
each sock, book, ladle, child-painted mug as reference
library? In this age of paring down, giving away, unburdening,
the house becomes still, the quiet after an organized tornado
spews its contents just so on shelves, in drawers.
Tupperware, oil-painted sheep murky-eyed with judgment,
inkwell filled with porcupine quills collected in Lazio.
What purpose does object compendium serve?
Racetrack table, Bulgarian tin compost kettle
(flea market find, used in our house only for décor),
scrapwood art slapped with paint remnants
(one project done on the racetrack table).
I dream of numbered lists, bindered pages, objects
in no particular order—stones the size of newborns
lugged back for bookends, collected with bone-
handled knives from someone's grandmother's shop
in Maine or London. These are not just tethers
to moving. Not only that. Imagine a ledger of yore:
leather, embossed, ruled lines and fountain pen
(blue body, broken brass nib on my desk, potential item #642).
Rows and rows of objects. I would tell you everything—
how and where acquired, purpose, situation.

This I envision: I am gone.
You or your decades-away
child overturns the wooden table and finds
taped to the bottom on yellow legal paper

to explain as you or they wonder:
This mahogany and oak bench, made with Uncle Ted
Westport. 2015. Designed as a bench,
we used it as a coffee table that never fit the room
but which made you proud. How glorious
these useful items, this object dictionary
(blue droplet lamp, noun, see: Great Grandmother,
Venice, living will, those Passovers and Thanksgivings
underneath its beads). How purposeful
to keep records of what we hoarded.
How useful to document what we made.

Biking to Uncle Teddy's Farm So Late
in June It Feels Like July

for Asa

Morning, we ride two miles on pea stone,
pavement, sand, and dirt to collect
just-laid eggs and overgrown lettuce.
One point nine miles, you say. We should be specific.

So let's. You are eleven and this morning
is desperate hot, skin sticking to seat, everything silver,
and I am mourning how the heat makes us
wish for cool, makes us fast-forward
(a term you hardly recognize because cassettes
are dinosaurs disappeared) to autumn, when this—
the only summer ever in which you are eleven—
will also be gone. How can we shift

from 7^{th} gear to 2^{nd} up the hill
past shingled barn, tomato stand, silo that could be anywhere.
Just how do we be specific, here, when heat, bug swarm,
march of time makes everything muck. It's hazy,
you say, sort of like hot fog, which is why I wore gray.
To blend? I ask.
To match.

Look, I tell you, bike stopped next to wild spinach which
we learned we should boil first. See how specific I can be?
I point to dandelion greens, burdock root, coral mushrooms.
You touch my forearm. You can't even eat mushrooms, Mom.
True, but still, we can look, identify, forage and find

words or eggs or the sound morning makes
in the bike tires softening on tarmac.
We're here, you say.
We are always here. Or I want always
to be here. To watch your now-small fingers
arrange each egg—mottled blue, underwater gray, sturdy brown.
Can we just keep them? Sometimes,
you say, I think they are too pretty to eat.
Aren't they? You study their form, memorizing their
egg-ness. And I memorize you—
it's not enough. Be specific. We still have
exactly one point nine miles back, eggs cradled
in my bike's basket. You tell me to go
in front. Watch for puddles, for cars,
for deer, for ticks, for broken glass, for
wild things and those who pick them.
Keep close, I say.
Or maybe you called this to me.

When we're back, bikes garaged, helmets
swinging from handlebars, lettuce washed,
carton of eggs normalized in the fridge,
you say, We should do that again sometime.
I want to say tomorrow, ten to eight. I want
specifics, too. I want to identify everything.
It will have to be enough, this morning,
just knowing whatever it is
in front of me.

The Geneticist and Surgeon Confer

Should you have a child?
How big is your body, how wide
your pelvis? Not for delivering
but for housing all of that offspring's
(and the offspring's offspring's) sorrows?
Think of it: each and every one of her
injuries (finger in the passenger door,
fishing hook cast to the eyelid) in your body,
her desertions, misfortunes, a pile of sharps
all nesting in your own lungs. The successes
are only hers. You are modern enough,
aware enough, mother enough
to give her those. But let's lug these
river rocks of hers as you consider.

Let me at least tell you this:
children are buried inside us,
our organs becoming tombstones,
markers of loss dug deep and noted
with dates, names, incidents.
How do these borderlands look inside?

What the biological hinterlands hold
only the pathologist will know.

Remember those tiny cocktail toothpicks?
Anemone-frayed plastic edges
in tawdry gold, blue, red the color

of old blood. We made signs for parties:
cheddar! Pigs in doughy blankets,

height of 1970s social cuisine.
Do you feel that kick? The urge now
to give a toothpick bouquet
to the white-coated egrets here.
To help them. To help label
what only we know is true.

On Spotting Stray Shoes

Of course not every lone roadside
shoe can belong to dead bodies or
lost children but it is easy to imagine
only dead bodies or lost children instead
of careless runners, sunbathers baked
enough to forget a sandal on the roof
which flings off like the end of August,
no warning, just a disappearing flip—
flopping onto Route 24 South or a mangled
hiking boot that could have trekked each
local peak, boasting six-pack climbs, summit
upon summit winding up chucked out
the window by an irate lover or
adrenaline fit. This is the thing about lost items—
we forget these small deaths, fling them
into the wind at sixty-five miles per hour
in order to keep going. Here, give me
an abandoned loafer, a guttered slipper
sogged with leaves, highway accessories
littered let's say unintentionally. Let's not imagine
unearthed limbs, motorway casualties, children
ragged and hunched with one bare foot
when these are only shoes—fashion, protection,
an afterthought to help us bear this cobbled world.

To Be Fair

To be fair, lyrics are no match.
I seem to know them all. Obscure
rockabilly, your grandpa's Odetta, Elvis
Costello, every Time/Life singer-songwriter in my head.
After the first birth, a friend insisted
we take an infant CPR class, as though this would ensure
we'd end up good mothers or that we somehow
could control what happened to our babies.
But with two fingers on the fake
though real-feeling infant sternum,
I heard the count, memorized breaths versus
compressions because of The Spencer Davis Group.
Don't worry, I said to other cross-legged
parents surrounded by plastic babies
and dummy toddlers, mouths open, agog,
desperate. Don't worry, I said and demonstrated
bum-bum-bum-bum-bum/breathe—5:1 and 5:1.
Just do the intro to "Gimme Some Lovin'"
and it will work out. And even though
I could not save all my children (not even close,
CPR doesn't work for everything),
now the yard rabbits hustle and pause
to our old albums, little darling, plucked
on acoustic or little wing thrumming into the sad,
hopeful end of August evenings. It's night
and I am on the porch, re-re-reenacting
how I save you this time. Here, all the songs
undone: the plane in "Fire and Rain" stays up,
the Talking Heads' house un-engulfed,

the Edmond Fitzgerald afloat, and Bojangles,
upright dog, shoulder-slung banjo hoof it out of my yard,
out the gate, up the street, leading rabbits
and ragged suburban coyotes and turkeys.
In one version, I follow, our sorrows brass-band loud—
bang crash slam, you can hear the notes of this story
on each eyelash, see it written in hair gone white,
legs ropy with muscle. Which class ought I have taken?
In another version, I watch the parade slink
out of my yard but stay on the wooden porch.
Maybe there's a breeze. Or nearby someone laughing.
Or a barbeque that because you aren't invited
smells good and lonely and like something is missing.
Which of course it is. Blinking four corner crosslight,
cars in unplanned swooshes, neighbors I don't know
flicking lights on in empty rooms. I find rhythm
in each sound, each action as my bare feet
on the porch ignore upturned trowels, soil bags,
too-small gardening gloves from our failed raised bed—
rusted bucket, bulbs half-chewed by woodchucks,
pulpy tomato plant ravaged by something
we couldn't catch. My fingers press into porch slats
as though the wood is sternum, and everything
destroyed is evidence of what we wanted to grow.

Notes to Self

Gas receipts scrawled on back—lettuce, garbage
bags, shredded cheese, remember to change

the minivan oil. Don't forget baby
carrots, yearbook forms, Blue Cross

Blue Shield (spoke w/ Jeanette). Buy
linen towels, bucket, mild cleanser.

Am I delivering an infant? One list
reads like operating room supplies.

Another as though sheltering from bombs.
Gather books, bedding, riot of pills labeled.

Backs of graded essays muddled with errands:
eye doctor, visa application, recommendation.

Consider contacts. Emotional? For the eyes?
Unclear. Bottom of my bag a list

graveyard, meals long ago cooked, eaten,
scraped from plate to dog dish,

seasons marked with bubbles, Band-aids,
snow pants repair, one child's fascination

with all manner of beans. Buy kidney beans,
cannellini, lentils, yellow split peas.

Dusty, desire—what is that word?
Supplements, hand soap, advice:

Reykjavik? Just write. Just breathe.
Talk more. Say it. Say all of the words

on all of the slips found in bag bottoms,
greased to floor mats, blown under tables,

caught in drawers. Say those shape-shifting
words: Don't forget to try. Decipher

whatever that last word is.

2

What can I tell you

except there is too much
spring already—damp frogs small as grapes,
wood hyacinth bright as sugared cereal,
fritillaries pink and sad-faced,
crocus woozy and bent—
dramatic, velvety like a Victorian lady
on a fainting couch, garish and elegant
at the same time as though we cannot
figure out what spring is,
because there's too much coming up—
which also means too much underneath.

Consider these mud-soaked survivors of April ice and boots.
What have I shoved away in order to let such stalks
bloom skyward? What if instead of bud and blossoms
earth pushed out your most terrible loss, your
weak, boneless flower of memory? Imagine
a field of diagnoses, of desertions, of children damaged
by other children or by the world. Imagine
you could mow over each and every ruined stem,
deadhead the daffodils of disaster,
reseed from the beginning just to see
if what grows is the same—
if those dark and bloody roots might grow purple,
garish and gorgeous, too, in their new skin,
their complicated spring.

The Passover Table

The plants—kalanchoe, gerbera daisy, Christmas cactus
given in irony last Chanukah—have died.
The children—all four—are alive.
We read Larkin's poem about spring each Passover,
but the magnolia tree has finally kicked it. We can live
with so little—meals cobbled from farm eggs
and stale bread crisped in the skillet with oil and salt,
miscellaneous donations of baseball gear, casseroles,
one entire kidney deposited in my body
from someone else's, a person I will never know.
Time for Seder, all of us tabled with bitter greens,
Charoset, and the flourless plum tart no one else knows
how to make—it will leave this planet when you do.
No one brought flowers—this is a blessing.
Shame I did not get your green thumbs. Dog, offspring,
mottled army of friends, cast-off family members
no one else wanted—those I take in, feed, tend to.
While, yes, I kill the plants. Neglect? Overwatering?
Drought? Extreme cold or sun exposure?
These are plagues we don't mention. This is how
we begin the meal. The plants, my uncle, and the person
who housed my kidney, they are dead.
The rest of us are doing the best we can.

Standing in the Kitchen with My Mother

Standing in the kitchen I'm with my mother and all
of her former selves I will never meet at the cocktail party
of photo boxes unearthed in the basement:
here is her Marimekko self of 1967—bullseye dress,
sad mouth. And here is the rounded-edged picture
of the paisley shirt I coveted in high school but couldn't have
because it was gone, like the girl who'd worn it—lost,
donated or forgotten at someone's farm.

Look at your knees on the porch that summer
when everything was still possible. My hand is flailing
as though you are the railing or even something more basic—
air, or breath in your pastels and cut-offs which your current self
would never wear. Here, you are in 80s regalia, shoulder-
padded and bronzed, younger than I am now. How
could that be—didn't we read an article about time's overlap,
light particles, energy waves lapping the shoreline of space itself?

We are all in this kitchen together—folk singer
with one clog missing, hopeful marcher, researcher
for a now-obsolete disease, even you on some
city corner grinning wide as your bell-bottoms. I am
tucked on your hip, you are egret-thin, unstraightened
hair clipped with something silver, hammered,
purchased at a craft fair or made by a friend no one
knows anymore. Even this friend who is not
in the photo is here with us as we sift through boxes, dealing
with moss-edged images, basement rank, and lost

time. This is the truth. We are all together
and it is crowded.

We are all in some kitchen somewhere
missing our mothers—the one we had or wished we had
plus all our selves. Can we all fit at the table, fit our faces around
the stovetop to taste a simmering sauce? Having arrived too late,
daughters will never know all the selves of their mothers, but mothers know
us. Know each skin fold, freckle, ragged heart. The good ones will ask—
have you outgrown your dislike of tomato, do you long for
such a simple dish, served warm and ready, as though
someone will always be waiting for you to come home?

Epigenetic Inheritance

Girls born to Dutch mothers in the famine
had greater risk of schizophrenia.
Fathers who smoked before puberty
had heftier sons. Just what

have you done? We don't know
how all this is passed parent to child.
Genetic information in sperm and eggs
shouldn't be affected by the environment

and yet here are lab mice. Here, too,
cherry blossoms. Think of it:
the Swan Lake of flowering trees,
the scent of which—when paired

with small electric shocks—trains for fear.
Even the smell without the pain
is enough to make mice shudder.
Then those mice have babies.

Their offspring—grey, brown, soft
as eyelashes—have only to smell
cherry blossom to twitch. The memory
of pain, revulsion, doom embedded.

How irresponsible these genes,
producing receptors that sense blossom
or mothering. Fearsome mystery
that inheritance of sorrow, unable to let go.

April in Wiltshire

for Craig

It is April and time for lambing.
In the muddy blocks of farming squares,
the full sheep kick each other to their breaths in labor
and begin birthing. Before midnight
I will go to those fields where, on this night,
a year ago, my friend and I last spoke.

I show my mother a photograph of him
after I dream he has come back to help birth the lambs.
In the light of the picture, we are in the July garden.
The mangoes we have for lunch are ripe,
shaped like punting boats on the Cambridge River,
oars dipping downward and grazing the earthy banks.
With a penknife we open the fruit's skin,
slice through the morning yellow of the meat
to the stone of their middles, pull the wet
strings into strips to eat and to divide.

It is because I am asleep that I feel his two hands.
I can watch them gesture like birds in landing
or touch them with my own. I do not wonder at them
not moving two springs later and it doesn't matter
to me then how many seasons are left.
I have not done the math of grieving yet.
That summer became all summers—*July, July, July*
heard in each oar stroke, each scuff on land.

Out in the dark the first lambs have come.
My mother reaches her hands inside one sheep
and pulls out a small, wet body, twisted in growth.
In the shock of air, it presses tight to the space
it came from, and we watch before our torch light
touches an orphaned lamb, its dead mother
spread in an arc on the ground. To give it a parent,
my mother kneels and slicks the lamb's new pink skin
with the placenta of another female whose lamb
was stillborn. With the hot scent rubbed under
their noses, they find each other and do not notice us.

On the walk back through the barn for our 4am breakfast—
brown eggs, beans, granary bread—I step over damp hay
and find a lamb lying almost still. In the firestick light
my mother shouts, "You'll have to fly her."
I grab the lamb by her tiny hooves, pick her up,
and hold her over my shoulders, swing her round
and round until the wind knocks her lungs
and oily fluid slips from her mouth.
When I stand her up in the field, she stretches
her tight spine, calls, and goes to the flock.

My hands are rough and cold and strong
as my friend's when he still farmed and carried
the lambs into the ditches for their first feedings.
In my dreams tonight I will wonder at his dying young,
eternally twenty. He is part of this place here, in me,
but part of that. And in that photograph of us,
in that garden where things were growing,
he held me. How he lived when he lived.

Mark Twain's ghost

appears in the attic—suited, unshaven—
and waits until I've finished
hand sanding floors (original 1890 pine, stained, lacquered),
waits until the room is ready to reveal himself.
Bed made, blanket chest heaving our wedding quilt,
reading lamp, extra pillows for the new guest room,
which Mark Twain claims, his face now
in the oval mirror neither my brother nor I want
from the discard pile of what parents offer.I take pictures of him,
send them instantly to my brother,
point out mustache, jaunty tilt of cravat, matted hair.See if you
can get someone else to show up,
he texts back. Maybe if I angle the mirror.
Maybe if the light hits just so.
Maybe if I find a rug. Maybe if I move
the luggage or tend to piles of old papers—
great grandparents I never met, term papers carried
for years, state to state, crisp-edged and graded,
photos of people I can't name
from trips I cannot even recall taking—
here, an easier, earlier version of me,
banana palms loose and flapping in the background.
Here, all the boyfriends, their letters, a baby
I did not have. Maybe if I get a window shade
or have a stakeout. How long to wait for someone elsebefore
accepting it's just Mark Twain, here to live

in the small guestroom at the top of the house
with no heat, no bathroom, not even a closet
from which to burst out and scare me.
There is no one else. We do not get to choose
which ghosts come to stay.

Ode to Everyday Objects in the Home

Sponge, blessed temporary keeper
of memories: scrum of sweet potato
and gratin of char. Scrubber of oil,
you are soaked less with praise
than with suds, saddened
as we turn off the taps.

Clothesline, with your wooden pegs
and the stray plastic rusted blue one
Grandma Bev stole from Walmart,
you are more timeline than dryer.
Think of it: cloth diapers, onesies
given to us by a friend I later cut out,
(a friendship appendectomy—
unnecessary, quick, scarring),
overalls I bought because they replicated
ones I'd had, though we could not rebuy
the train conductor hat or defend against
the days that scampered before the kids were born.
Line, you rippled, graceful, stringent in warning:
do not go slack in summer days
when everything dries before
you've watered or pruned. See there—
the vengeful squirrel who nicked from the rope
my daughter's blanket (barfed on, washed, hung out
and gone). That item we would have saved.
Would have folded into a trunk
so that she could later find it—adult now—
and be both sad and horrified by her own sadness

and by the dankness of time and other people's
version of what to keep. This is you,
holder of laundry and outfits out-of-style
regarded with pity in photographs
of sheets sweated in and jeans gardened in and
shirts worn to repair chicken wire or worn
as toddler nightgown. End to end,
this rope, this airy tenter, suspender of days.

Dryer lint, my grandmother collected
your tufted remains for purple martins.
Balled up, saved, nested into gourds she grew
only for hollowing and sunning
until they hardened. The birds—
who never thanked her—allowed others
to rent their hard-shell gourd for a price:
yarn, crickets, mussel shells picked clean.

Buttons littering drawers and cookie tins,
I cannot use you for mending (mending
gone out of fashion—cheaper to buy new).
Jumble of homely items, housed within
houses. The children ask: how many
of something does it take
to make a collection? Objects
around me, your use, I could go on.

The firefly in my yard

has fallen in love with my internet router,
a device I could not name,
had to ask my friend, another writer, Midwestern,
who understood this creature out on the night lawn
which is itself overrun with rabbits and old tires
my son rolled here from the mechanic shop
to practice spirals for football games
in which he will never play.
Through this family of tires, a lone firefly
blinks, flits through summer darkness,
struts its firefly self each night—look here,
look at me—in conversation with my Apple router
that presses up to my office window.
Everyone, all of us, hoping for a response.

Thoughts Upon Hearing That You, My Former Shrink, Have Died

There was the time my bike shorts and thighs
stuck to the chair and I cried
because the skin adhered during my 50 minutes,
but you thought I was (at last) tearful
instead of sitting saying nothing (which of course is
not nothing but something).

There was the time when I told the story—
beginning, middle, end—of my son's rape,
the damage marked by the pediatrician,
clinical drawings I did not wish to see.

There was the time you finally spoke and said,
You need to think of something to eat.
That was the entire session—the two of us
coming up with something
I could fathom eating. No surprise to find us
settling on food of our respective youths:
dark pumpernickel bagel, cream cheese schmear,
lox bright as sorrow, bright as the birds
of paradise, purple phlox, gaudy begonias
that appeared each week in your cylindrical vase.

(Or, I assumed the vase was yours, even though
I learned we ought never to make assumptions.
That they kill relationships, strip them of conversation,
bloat the silence. That's what I got most from the sessions,
how crucial the collecting of words.)

But also there was the time you fell asleep
right in front of me. Hilarious because I was afraid
of being boring. And because of that fear,
I cherry-picked stories—my grandmother's vitriol
despite her enormous vegetable harvest,
my husband's heart like some remote island
I had heard of but couldn't place on a map.

There you were nodding off
even when I last-ditch effort told about an erotic dream.
The stalker I'd had maybe or some other
long-gone man. Snore. Head lilting.
And the worst part? You never apologized.
Who sleeps during a confession?
Was it warm in the room, my husband offered.
Can you blame a guy in a warm room, 3 o'clock?
Don't our bodies instinctually shut down then,
remembering the child we'd been, napping?

(My therapist friend told me shutting down,
sleeping, drifting are topics discussed in training.
We study this, he said, Because when we cut out—
that says something about us. About you? I asked.
How is it about you? Just who is paying for what here?)

And there was the time I saw another author
in the waiting room. On stain-resistant chairs
we plotted a story we would never write.
Imagine: all writers see the same person,
tell the same sorrows, so that someone—you—
will gather our words and make them
into something that resembles hope.

Labor Day

Those fast-hearted hummingbirds
we baited with sugar water and syrup
flit, restless, especially next to our porch.
Our bodies are overly sunned, save
for the sections covered with newspaper—
travel, week in review, styles, business,
water-ringed, littered with lemon slices.
We cannot know those moments
of languor until they have ended.
Sun belly up, crusted garden remains
slicked on enamelware plates cracked
at the lip. Beginning to rust.
This is what you will want,
what you will argue over: who
gets the broken bowl that cannot
even hold cereal gone soggy?
Who takes the bird feeder back home
to where there are no hummingbirds?
Only water and syrup and sugar,
which all seem—rather suddenly—useless.

In Praise

No one praises the nostril.
Overshadowed by tufted nastiness of age,
crusted muck of childhood. Where is the joy
of newborn neck, smell of milky morning,
inevitable scent of your mother's/father's/grandmother's/son's
lotion/cologne/maple syrup/pomade?
Could you spend a few moments thinking
of those once tiny nostrils—now larger,
that we learned not to stick things in,
haunted by what has gone but that we still want—
that mother and her lotion,
the high school boy who drowned—
bourbon soaked, in the reeds
what was that smell he had?
The betrayal of age is the smell.

Let us praise nostrils for what they are—
time travel, gateways to every meal, place.
This is how you bring back the dead.
I'll cast no judgment if I find you hunched over
a bottle of vanilla extract or your son's sweatshirt or
your grandfather's gardening gloves.
There will be mourning for empty biscuit tins,
trowels still woozy with dirt, each salt- and snow-stained boot
the size of your palm, for even the dishrag's rank and pong,
box of undone slithering bowties, swaddling blankets

that could not possibly hold the nostril's gaze.
Afford the olfactory a moment,
give thanks for those gateways, consider
the spaces carried each day in the center of us.

A Cure for Grief

There isn't one.
But here is a pot of jam,
apricots plumped with booze,
lemon rind, sugar—
the stuff of August evenings,
dirt road trimmed either side
with heavy woods that narrow, give way, finally
funneling to ocean. To the house on Buzzard's Bay—
deck built, rebuilt, expanded and rotted,
built again, everyone toe to thigh on chairs
(neither comfortable nor attractive), scattered railing
to sliding door each afternoon as we scrubbed clams
collected in low tide or painted rocks or read the news
or stared out as though we knew it was always
on the verge of ending. Those nights,
jackknifed open with wind and visitors,
dinner not yet cooked, not even paid attention
to more than someone asking someone else
what was ready to be picked;
green beans knocking together like wind chimes,
knubby new potatoes, one summer's experiment
with asparagus that we never trimmed—
each stalk pushing and protruding until it appeared
some creature had clawed its way up from the earth.
How long would it visit? We could not bring ourselves
to cut, roast, salt, and eat it. Can we ever digest
the piling of days we hoard inside?
Now I offer this: apricot jam from last summer

that we did not know was last. Your instructions:
unscrew the Mason jar (it, too, cribbed from the Cape pantry).

Each morning you will awake alone. This is when
you dip your teaspoon or knife into the jam or even
your piece of actual bread (no one is judging—
suspend the crust directly into the jar).
Taste the apricots. For this moment have summer—
and him—back. The jar is large. So is grief.
This is what you will taste each day—
fruit slipping against lemon, and sugar, and time.
When the jar is empty, days will have been gotten through, too.
That porch, careening as though he—and the rest of us—
were already gone, suspended right there at 5pm,
drink in hand, sun still up, children barely grown.
Eat the jam. This is all we have to offer.

3

What We See

1.

How about that time we stood off-season
in wet sand as waves tossed
a garbage-bagged body?
Cell phones didn't exist so we discussed
just how long we should stare at a murder
disposed of, tarped, and chucked
before calling for help. And it's good
we talked, because while we talked
the body became a harp seal,
jack-in-boxing up, carnival-eyed,
all of us surprised by being seen.

2.

Convinced we'd spotted the cephalopod
from the air, we shared a moment of secrecy
on a jam-packed airplane, all of us crated together
like animals en route to a factory farm,
this creature below our own saving grace
except that squid became eco cabanas,
each pod connected, rafted, floating elegant
and marooned. We brushed off our foolishness,
but as I waited for the boxy bathroom,
I saw how easily we'd been mistaken,
just how plausible our folly—mantle, tentacles,
head, and arms. How close we were
to Father Island, Chichi Jima, where the only one eco cabanas,
was caught on film, preserved, revered.

3.
What about when you swore
the baby had grown a beard overnight,
transformed into a onesie-clad woodsman?
And the next night, same thing—
shaggy, shedding blanket knit
by a high school friend I'd ditched
before this Paul Bunyan baby insisted
on growing downy facial hair in her
basinet. We gave away the blanket
soon after. Now maybe someone else sees
what we saw. Whatever we think
we see is what we see.

Progress

Great Grandma Tilly warmed her bed
with baked potatoes. My grandfather

carried in his pocket a slide rule
and when he could not breathe

invented glass asthma inhalers
delicate as herons. My parents

queued for an hour at the bank
on Fridays to have weekend cash.

What do my children do that theirs
will never? On what will we overlap?

The way my parents and I shared
albums, records housed in wine crates.

Self-drive cars? Too late—they've driven.
Renounced tradition? They've said

Kaddish already. Used teacups for bisque,
slopped baked beans, old cheddar,

baby greens, and egg into a bowl
for a concoction we haven't named.

Will they recount that recipe
to future loves? What skill or object

will be obsolete? They won't recognize
anyone's handwriting. David's

curved *a*, Taylor's loopy *y*, Jen's entire
jagged alphabet. All texts now look

the same, but I handwrote notes
and letters—on IHOP menus, motion

sickness bags, matchbooks back when
matchbooks still huddled at the front

of restaurants, hoping that someone
would find, collect, and save them.

Spoons

My mother is so drawn to spoons, we have forbidden her
from gathering more. Wooden spoons collected
into kindling cords, tied with twine, nesting by the unlit fire.
Bouquets of metallic spoons in jam jars on the sill,
drawers of mixed spoons, decorative cutlery, a lone spork
which has for years waited for another of its kind
but is alone. As toddlers, the spoons were useful:
feeding mashed peaches to my brother
or from the refrigerator cold, rounded ends to ease hives
or cool my eyelids. Also drumsticks on Tupperware
and a train of spoons laid end to tip across the living
room one day of endless rain. What is it with you
and spoons, my now-teenaged son asks his grandmother.
As she displays for him her latest catch: mother of pearl
gone cobalt and fuchsia. Thumb-sized, these are meant
for caviar we will never eat. What is it with her and spoons?
She doesn't know—addicted to their shape, she offered once.
To their usefulness? They don't take up space,
she tells my son, but he disagrees—everything
takes up space. But they take up small space. They need
nothing—no watering, walking, reading to.
So this is what she has: piles of spoons, gentle clusters
that can neither grow nor walk away.

Eggs

My father cracks eggs with the precision of a thoracic surgeon
(though this is not his specialty), scrapes one half of the shell
against the other to make sure each bit of white is used,
stirs yolks into dark batter. It is the first recipe since the burial.

His hands have the texture of dough left to rise too long.
The index card indicates stirring this a long time—
How long is long? my father asks and I tell him,
That is too philosophical for me to handle now.
My brothers and I abandon the cooking to sit—kitchen table,
no food between us, no coffee or water tepid from the tap.
Two clocks—a black round diner-style
over the doorway and a travel alarm clock that used to be
on her nightstand but is now by the sugar bowl—each tick
a different time. What is there to tell?

Except the nonsense of batter and clocks,
of images my father explains—epidural hematoma,
blood clot seen on the surface of the dura, suggestive
of trauma, a resulting tear in the meningeal artery. Or the Circle
of Willis, the beautiful cerebral arterial circle supplying blood
to the brain, but looking like a frozen stem of pussy willows.

Imagine your mother's head filled with this bouquet:
each aneurysm clinging to its own branch. And more—
the art show of biology, duret hemorrhages in the pons
identical to cross-sections of thick wood, that slab of redwood
still on display on his desk, the rings irregular and mottled
maroon, the center gold. Patients come to their clinicians

and my father translates, the tour guide of deepest continents,
making sense of jargon presented on each slide or piece of tissue.
Now he misses the art of it, visual beauty and horror contained
in each bit of urine or blood, but cannot look because
his wife is gone. We try to engage him in baking, activities
that busy the hands, quiet the mind. I've been fixing clocks!
His announcement and subsequent showcase of the study,
her shoes still cluttering the doorway. Outside the room,
the ticking. We can feel it, too. When he opens the door,
syncopation clings to us like mist, envelopes us in sound.
Clocks, some the size of a tea cup, others tall as trees
standing, covering the sills, the tables, armied on the floor.

My father who spoke so fondly of his med school cadaver,
helped birth us, too. Now he reaches his hands inside
a bell-shaped clock, its small glass face brought to life now
by whatever tinkering he performs. Belgian. Circa 1936.
All that way, only to break in New Jersey!

He sets it down on the card table in front of him.
None of the clocks are timed together, so each second
muddles with tocks and clicks, ponging bells, whirring gears,
unplanned bings. I am off-kilter here, can only stay
for a few minutes before agitation, my mouth taut and dry.

You are not here to offer a drink, to ask what we need.
To decipher the clocks. Dough rises in the kitchen, beaten and kneaded
chemically-activated by yeast and sugar, the stuff of growth
while the clocks conduct a countdown symphony—
their own language: blastoff, wait, stay right there.

Upstairs, My Family Sleeps, But I Drink Coffee and Write Instead

We like the partial view, the open plan
allowing us to see from one room to the other,
as though we always need to know what is happening
by the piano or tin-topped table
that came with the house and which
we planned on selling or moving to the basement
but which has remained in the family room.

But here is the design flaw:
from the kitchen we can see nothing
except the kitchen. Bookshelves with recipes
I do not follow, mausoleums of meals the kids
marked with oily fingers or corner-folded pages,
the temperamental stove and wooden
tongs my uncle made for me to use
but which I can't use because they are too beautiful
and delicate and I worry they will snap,
which makes them useless or functional art
depending on the day.

Still, there is no view of anywhere from here
except a partial look to the street
out the entryway window—just a slice
the shape of a 2x4. Branches, whatever
weather sky, tip of a house up the road,
telephone wire that could be branches
if I were to get up and really look.

After Teaching at the Writing Conference
on an Island off the Florida Coast, We Eat Dinner

1.
Here is a white mustached poet married thirty-six years
and a slim faded rock star in jeans, thick-framed glasses, shoes
better suited to our teenage sons. Sneakers bright as candy
wrappers on my left and Hawaiian shirt on the right.
What is it about islands bringing out fashion misfortunes?

We are a vaudevillian act—our sorrows bared for laughs.
Poet and musician are timeless here as though they've
been at this exact table for decades, examining menus for line breaks
and rhyme. The poet weighs fish vs. shank—for health reasons.
The singer cannot commit to any order because, he says,

each dish might be better than one almost chosen before.
The rock star will love me or think he has a chance with me or
not think of me ever again. The poet will leave the conference early
when his friend dies, will be in a bowling shirt when he says goodbye.

2.
The rock star likes peanut butter, asks if I have had it with steak,
which I do not eat anymore. We want what is gone. Right
at this table, aging, laughing as we pass whole grain bread,
sponging olive oil, whatever is good for our hearts. This is what I know:
everyone at the table, the conference will die. Have we always known this?

Yes. Or, not really. We want to teach the craft of cutting and building,
understanding tension, to become such experts we can never be surprised
by our own plot. But the rock star is not my husband. His face needs spackle,

sanding, the stuff of practical workers, construction, drywall. He has stopped
drinking. But the poet can still drink, bikes daily, married to a triathlete.

3.
The poet and I are smug about our happy marriages. The rocker
and I do a close reading of the menu. Too many words on top of words—
dusted with basil, rolled in pistachio, encrusted with horseradish.
Overcompensating, he tells me, his lips too close. The same voice
from the radio slips into my ear, my cheek, chin dusted with each word.

In Spain the olives aren't canned. Yes. Backstage, I need the quiet.
Yes. In Spain, I have *boquerones* —marinated fish—on toast
for breakfast. That's healthy, isn't it? Yes. And even there,
I would clean up the words and oil and you would be
in AA and we would all be mortal.

4.
Because he cannot drink, he still smokes. It really is like 1978
here, isn't it? Yes. When he leaves to smoke, I order him
peanut butter pie. It is the least I can do for someone who regrets
each choice. Also an excellent cover for my heart which sags next to him
because he was on stage and now sits—mortal—at this table and

because he writes aching music and sings with grace
because the song he did not perform tonight was the soundtrack
to my drives from home to hospital when my son was living there.

5.
You are getting the peanut butter pie, I tell him. We are
arm to arm at the slab table, poet to poet, singer to memoirist
as though the iceberg has already hit and we are treading in dark water.
You two are married? Someone asks of the rock star and me
as though ordering food is the most intimate act around.

I'm allergic, I say, meaning the peanut butter but the rock star
thinks I mean him. I wasn't always, I tell him, I know what it tastes like.
That's worse. He whispers, Don't you crave it anymore?
I don't know what to want, I tell him.
Still smug in our respective marriages the poet and I split mud pie.

6.
Both desserts arrive at the same time and we cannot tell which
is which, mud or peanut. They are identical down to the crust, cream
beige interior, vanilla ice cream sheathed in chocolate shiny as new plastic.
The poet and I think our pie is better. We flaunt our words.
The rock star orders more. Because he can. The poet judges.
Our way is better because we pocket the longing.

See this? The rock star points to a scar near his nose.
It is a beautiful nostril, I say, even though he cannot recall
how or where the scar became a fixture. We want what is gone.
We want the rock star and the poet and the pies, too.
We want the students to understand structure—
words upon words, the poetry of menus architecture
of decisions, scars, that misplaced punctuation of desire.

Remembering T. Lux

That sunlit room, its air filled with dust
and words, each light shaft like some old-time
film projector. This is how far back it was:
you let us smoke in the room. Only that
first year, but how writerly it felt, ashtrays
and poems in front of us, you in front of us,
long-haired as though you'd read the manual.

You might have had a tawny corduroy jacket
with patched sleeves. Or this might be
one of those tricks of memory. Maybe
you didn't even smoke by then, had moved on
to toothpicks. But maybe I remember.

Or maybe time inserts details never there
in the original. Your lungs didn't hold out.
Probably this is something you would have
penciled through, edited in our conferences.
It isn't necessary to know how you left, I guess,
only that you were there. That you had words

and let them bounce or swirl in whatever
light came in. Maybe you had a vest
like a blackjack dealer. Maybe you shared
your cigarettes or—if I recall correctly now—
you quit and carried with you conjoined
wooden picks. But it didn't matter.

Your lungs were already speckled, lit,
though we didn't know it. And if you'd tried
to explain to me then that I would eventually,
inevitably mourn you, I wouldn't have understood.
You would have gone on to say of course
I wouldn't just be sad over you, that it would be
all of it—autumn slipping every year, late

teenagedom gone and how impossible
to know how to punctuate or where to break.
Words can only convey so much. But they
were so much. That's the thing. I swear

there was smoke and your blazer,
that it was always fall and I was young. You were
my age now. This is what I would ask: why
do we write about people after they are gone?

Can you just edit that for me? Make those alive
notes in the margins? Your solid poems
were made of junk store items, objects
or creatures unearthed at the town dump—
lawnmowers, wheelchairs, bees, scraps.
Useful things. That's what we're left with—
You, that light, those words.

3-Body Problem

1.

Say you and you and you
meet at work (sub in coffee house,
support group for someone other than yourself,
line at the bank, cinema, lumberyard).
Or maybe you already knew them
from work at the lumber yard,
coffeehouse or high school
but just say you and you and you
and there's already a problem.

2.

Say you are a physicist (someone is—why not you?)
And this you understand:
It is easy to calculate the earth's motion around the sun
if there are no other bodies in the solar system
(but there are other bodies, as we've said) and also easy to calculate
the moon's motion around the earth
if no other bodies in the solar system (not even a sun) are there
But. It is very difficult to calculate the motion
of the moon around the earth
where there is a third body in the solar system (there's that you, sun).

You and you and you, 3-body system of earth, moon, sun.
You can observe strange oscillations
vibrations in the moon's orbit around the earth,
measuring with the naked
eye as long as you have a reasonably accurate clock.

3.
So now we put this into your story—
Physicist, Plumber, Husband—
the motion of all three difficult to predict.

A more apt analogy would be the motion
of a planet (husband) around a sun (physicist/wife) when a rogue
planet (plumber) enters the solar system.
In some cases, the rogue planet will simply pass
through the solar system, causing perturbations
in the planet's orbit (which may or may not be catastrophic).
In some cases, the rogue planet will be captured
by the sun (does she kill him in the basement with his wrench?
The plunger for humor?)
but this means huge perturbations in the planet's orbit.

Or maybe the rogue planet causes the husband planet
to spiral out of the solar system (depends on the mass of the rogue planet).
Or maybe the damage is too great to calculate.
Even for a physicist.

The point is this: in the coffeehouse or DMV line,
at work, cinema, garden center, lumberyard
with its wooden planks, solid and touchable—
Move along. Move along. Move along.

Instructions

After shelter/food/water,
you must want something.
Oatmeal, job, firewood, nail clippers,
Clean kitchen, debt-free living, mouth
on yours that wants to be
on yours. Skillet in which bubbles
chocolate chip cookie dough
to serve to the mouth on yours
after it undoes itself. Or you want
a Phillips head screwdriver
to fix the wonky green bean
planter cobbled from old bed frames
left to wither and bleach
in the sun. Lumber leftovers
someone else did not want which
give you what you want. Longing
is necessary. Want something
let it lap at your feet, slip,
pull back, come back with
more. Want. Or if you cannot—
want to want something.Enough
to propel but not so much
that you slip into the hole—deep,
desired. At South Beach that day,
we thought we saw a trash-bagged
body floating in offseason water.
It was a seal, waiting for us

to wave, and when we did,
it sank into an unseen world
which might be a place
you want one day to see.

The One Item

If you were going through someone's belongings—
estate sale, grandmother's cupboards, boxes of disaster

relief, Uncle Alsheikh's sea trunk shipped
(Valencia--->Lisbon--->Kochi)—no matter

which pile hulks in front of you bearing notes,
fragments of elsewhere life, take the skillet.

It will never fail you. I have three: a 12-inch in which
I have made biscuits, beer battered cod, peppers

shaved eel thin, omelets of vegetable drawer remains.
Then a smaller one from central Texas. Note

its peculiar square shape. I went back-and-forth
on this one under that junk tent. Who held it?

What damage did they cause, or what good
did they put in the world? Had they cooked with lard?

Had they met a Jew? Would they be amazed
to know that from that flea market I picked up

their old pan and carried it with me on the plane,
flight attendant with raised eyebrows wide as fried eggs.

Last, Nana's tiny one. How on earth did it survive
her lack of cooking? Her oven used for storage

of shoes, shut-in existence post 1939. Advice:
take something useful and use it in a useful way.

Re-season as necessary. Take the skillet.
Pot, weapon, doorstop. It will never fail you.

Fry the eggs, bake the biscuits, slip the salmon
into dill oil. Tangle the greens, use everything up.

Make as much as you can for as many as are left.

4

Moorings

Suppose you say water.

We're on the boat, making for Babson Island, one of three tiny beach slabs that connect at high tide. We set anchor, mark the drift, account for wind, row to the shallows. This place has sand dollars. You find some, bring them to me. I will wrap them in tissue to assure a safe journey, feel something split in me when one breaks years after the moments on this island. It's funny how we know these things: a song will have meanings we can only guess at, the strains of trumpet or your daddy's rich and your mama's good-looking making me curl like a fist, the smell of soap, or brie cheese, these things will kill me later, but we don't know this yet. For now, we're still on shore, collecting things. Each piece of kelp, a misshapen shell, the sand dollars. I want to fill my pockets with them, add them to the collection of you. Even broken, these objects will rest on the mantle as unruined remains.

In Mexico, we climbed the ruins at Chichen Itza, looking for a history unconnected to us, the steps so steep we moved diagonally to avoid falling. At the top you leaned back onto the old pillars and reached for my face as if we were the pinnacle, as if we would be cast there for the sky, for the tourists to admire. On the plane you drew for me a dog and a dragon, creatures not meant for water. I keep the papers, trace the indents from the pen with my fingers to feel where you've left your mark. My mouth is still yours, my insides changed as if the stones of a ruin had molded to us, and we had swallowed the image.

To say water now, in all its forms, is to bring an image of us at the edge of something. I imagine you in this water. Do we meet,

tethered together as if moored to the ocean floor? There's the mahogany box you made for me, still filled with receipts, notes, letters—proof.

It's all water and movement and the rushing of what we have collected trying to mark the set and drift of these tides, the undersurface mountains of silt that peak just before they give way to water.

Postcard to Breezy Point

Knees huddled by the coffee table,
we played board games in the dark

that continued to be dark
several nights running, until

we'd used up our candles
and our Swedish friends wondered how

it was possible to run out of candles.
Weren't they necessary items

for the home? Didn't we always, always
have more? I couldn't reach you,

assumed you'd been called in,
a night shift that leaked

into the day and back into the night,
you in your pool blue scrubs

and sloppy bun, reaching into people—
actually inside bodies to grip babies,

suction, swaddle. You, a birthsside

carnival barker—here is your door prize,
your winnings, your take-home

human. But you had not been called
to work, instead reaching up inside

yourself—and this is what I see
even though I don't want to:

your picnic table slams through
the front window, waters rise so much

the sofa blocks the front door,
maroons you in, laboring, upstairs

in the bathroom, damp slipping into places
we hadn't thought of as empty—

the seams between kitchen drawers,
each pair of shoes, hiking boots

we traded in Iceland to avoid blisters,
the laces moldy by the time I sifted

through your stuff. There was nothing
to keep. I played Life, Monopoly, Risk

with my children in the dark. Here,
look at us: we are hiking in fields

whose names we cannot pronounce.
You have on my shirt. I am reaching

for you or stumbling. We are either
heading up or back. The breeze

catches your hair, sends it skyward,
and I am next to you. What would I tell you?

Each photograph, whether we know it
or not, is before and after.

Passover in Jamaica

That time we buried the skull
in your backyard, moved aside compost—
slackened greens, chicken bones, pencil nubs,
hefts of coffee grounds still wadded in their filters—

to clear a spot for what you'd found. If the body
is a temple what is the skull, then—pulpit,
bimah, dais, pew with vacant gaze?
Here is the cemetery of our pasts,

the dot-to-dot of ancestry—Jamaica
to Florida, Russia to South Africa, Pskov
to Brownsville. The dots are skulls or arrows,
flowcharting our genes, all ancestors dead

and gone so we can make art in America.
In our palms we held them—antirrhinum,
snapdragon, dragon flower. There,
huddled together, immigrant growths—

yolky yellow, orange as ackee fruit or salt lox.
Told the blooms would make her appear
fascinating, your great-grandmother
concealed them on her thigh, just as

my grandmother hid American currency
rolled up in her vagina when she fled.
What to do except bury the pods in your yard?
Dropped by the handful, tiny skulls,

a mass flower grave of everyone gone
to seed. We wanted to write about it,
to have the words. What did they—do we—
hope, exactly, to be remembered or to be free?

Seventeen Ways of Looking at a Crime

for John M.

1) Of course you didn't do it or

 2) You didn't mean to and

 3) your brother
 shoplifted that bottle
 opener without knowing
 its use while

 4) your
 grandfather slipped albums underneath his
 peacoat and then felt too guilty to play them

5) Thank God you are a minor and/or

 6) The DA did not pursue because

 7) You could not
defend yourself (big enough, yes, but verbal, no) coupled with
what she calls illegitimate memory, shape-shifting details

 8) So, in light of these
findings we

 9) Release him home (yard,
porch mucked with wet leaves, deflated soccer balls, lost Frisbee
body unearthed in March)

 10) You will be fine

11) or this will never end and we will spend all days (part, some, all—a hummingbird dart of wonder at least) querying 1 or 2 or

12) You did it. And now what? Ensure comprehension? Trust therapy? Cage you in some form of item 9?

13) No. What do you recall? Rosehip lotion/slack-jawed leeks/guitar string used to dry garlic, not what occurred in the room itself

14) Who you were before or are still now

15) after or now whichever is easier to say

16) which is to say how can you know and just what would it change? Four years old you screamed at the ocean, desperate to inform each surf slap on sand—afraid each wave was the last. What did you scream? Do you remember?

17) Come back come back come back.

Flowers in Odd Numbers

In my childhood house,
my mother's Victory Garden sketches
also on the shelf, watercolors of first
forsythias, chick yellow, pointed crocuses
nosing up—is this the spot? —as though they might
reconsider and sink back below.
Grow it Inside, a manual for seedlings,
hard bulbs, clipped cuttings
(and cells that divide and divide inside me).
No one knows but us.

We read an article about mothers
absorbing their offspring's DNA.
About mothers passing on decades-old trauma.
So if your great-grandmother escaped,
you did not. Crocus next to rhododendron
(easier to grow than to spell, she'd said).
Give flowers in odd numbers, she'd told us,
Or you will offend your relatives—
And make a lousy bouquet with no
focal point. Most flowers come by oddness
naturally—their petals prime or odd at least.

If my mother is not here, who will show up
to bring me flowers when I am vacuumed out,
cells gone, clean, neat, dark, unseeded?

We lived by the stuff of water at this house:
currents, swells of mackerel, jetties.
When we were children, my mother
walked us in the dark to say goodnight
to the river. She slid her palms across mine
and I did not know of the journals being kept,
the decades-old flowers I would find,
those shrubs of distance,
the looseness of something leaving.

The Social Life of Trees

How will you say it?
Use these words: kind, gentle, bright.
This is how mothers describe their children
and how arborists speak of trees.

Walking through the Public Gardens
in a January that feels too warm and probably
signifies the end of the universe
or at least weather patterns as we know them,
I talk to the trees, six hundred of them here.
Kind. Gentle. Bright.
What else don't we know?

Despite elm disease ravaging,
the specimens are all noted and pruned,
arranged like girls—flowering ornamentals,
shady beeches, lindens, ginkgo, dawn redwood.
Trees recognize their offspring,
talk to them, send them more carbon
below ground, reduce their own roots
to provide space for their offspring.
Douglas firs speak to their own—connect,
network, bend branches to avoid blocking light.
Just what is each tree saying here, bare this winter?
Just how can I explain you to the court?

Past bronze duck sculptures
based on a charming storybook
I will not read again until if and when

I've become a grandparent
(oh for those early infant days,
mush of sleep and peaches, gross motor
benchmarks, milestones, delays, failure to thrive
all in the rearview now, impossibly far away
even though I am in my early 40s). No one
explained this to me—time collapsing
in on itself as I raise humans who ask,

How do whales breathe, what are square roots,
can I dye my hair/text late/be someone else,
do new math? Will we always have food?
What constitutes bravery? What if someone says
you're ugly? What if they hate you? What if
you by mistake hurt someone?

The statue ducks have on them
out-of-date knitwear: thin, buttery colored scarves
finger-knit by toddlers, misshapen pom-pom hats.
Often, one duckling goes missing,
a favorite of local thieves and college students
playing pranks. (Pack? Mack? Lack? Which one?)

Here's a man playing acoustic guitar,
tambourine strapped to his foot.
How have I come to be singing next to a stranger
in the park, on the way to see my mother?
How did I ride the trolley all the way here
without speaking to anyone around me?
How are we singing "Get it on, bang a gong?"

This is the only song I know, he says to me.
I sing some words—overdressed

in my smart wool coat and boots. He can't know
about the lawyer meetings left behind,
and I don't know his back story,
the words he would choose or be instructed to use.
And I don't know why he does not know the end
of the one song he claims to know. Maybe
this is the trick. We don't want to know the end.
Who ever really wants to know how things turn out
for the trees who socialize privately in public,
for the singer, for the missing duck, for me
or for the child and those meetings?
Let the jangly music and spaces
between the ducks and time's collapse continue.
Let us not know what is really being said.
Let us not know how this ends.

Morning in Ushuaia (After the Court Hearings)

We have come to the end of the world
to walk with penguins on Martillo Island
to watch the hatchings, and so I can slip out
of my skin and start again. Green slips of beach reeds,
barren knubby heaps of rock, new eggs,
shore bound animals learning to take care.

I watch these creatures as though they have answers—
feathered rookeries, parents alert to danger,
chicks who understand already what will save them.

What would I say to you (you who is now merely tethered to me,
12-year-old akimbo in space, cheerful with Pluto or crying
for Jupiter and those gorgeous rings)? That self and my other selves:
Oh, if I could warn you—keep the door closed? Or, later self, keep
your son's door closed? Do warnings protect
or just state the inherent danger
of being alive? How would I tell you (myself)
to protect us back then
without undoing the you who now knows. This is the broken
tether and ache of floating in space with all of our selves.
So reliant are we on each ruined ding, each ring—so present,
so there we can always see but never touch it.

How much of my current, earthbound self is built on earlier disasters?
Among the Gentoo and Magellanics I imagine
alternative timelines in order to avoid ruin. In this one
doors are closed, locked—the neighborhood filled with wild coyotes
instead of humans. In another, skúas, petrels, cormorants, vultures

and South American terns speak for me, pecking eyes, swarming
as needed to rescue me. I want to thank them. Such good
and tragic and timelines on offer here that somehow avoid those nights
as though it is always morning and always there are penguins. Of course
this isn't possible and I know disaster is coming. Mine, my child's
brokenness. This is how we watch ourselves—after the fact
a strange and hopeful vaudevillian act—sorrows bared for laughs.
Here is the Beagle Channel. Here, too, my family of humans,
of selves past and present, of warnings, desires, survival.

Here are words I don't want to write

about the saguaro cactus
which takes ten years to die.
You took three months,
arms wide out, stretched.
Sometimes saguaro are just spears, armless plants.
Maybe an arm at 75 or 100 years.
And then 50 more years after that. Imagine
Cave Creek, Arizona, 10 feet around, 40 feet tall.
Like you, an entire forest
in one specimen, arborescent—
surviving draught, disappointment, disease
for a time. Hello, white flowers,
blooming April, May, June.
Months with girls' names, you said.
Goodnight same flowers that close
as the sun fades. Hello, honey bees and bats
who help pollinate. Good morning, white dove,
black-chinned hummingbird.
Top of the morning to you, gilded flicker
and house finch, lesser long-nosed bat
out at the wrong time of day, so content to nurse.
Come to me, edible fruits that cannot be picked,
Gila woodpeckers and wrens and elf owls nesting.
Goodnight to you. Goodnight blossoms and arms
attempting to grow skyward. Goodnight
tall specimen of strength and prickles
and evolutionary exposition.
Goodnight, well of water still inside

as though you had more days. More to say.
More. Goodnight scruff of beard and watery eyes,
hands that held mine and heart beating desert to night
goodnight goodnight goodnight.

How the Jews Say Goodbye

You will have your coat draped over one arm
like Peter Pan's shadow, limp and dark.
Also in arms this oval dish
in which you brought *tsimmes*,
apricots plumped overnight,
shoulder to shoulder with carrots and prunes.
Perhaps you will also carry leftovers so warm
they can hardly be called leftovers.

This is how Jews say goodbye.
Not as a farewell but what will you bring home?
Just what, exactly, have you eaten
or held or discussed here—
as your mother-in-law has dug into the skin
of your parenting, cousin has had more than her share
of wine (to be fair she is only part-Jew,
thus the gathered know her inclination
to drink more than overeat), children
growing and evaporating before you
like a science experiment or magic act?

You have your coat, yes, and warm dish
but this is when aunt or brother or friends
assembled here for freedom or Shiva or breaking
a fast you did not keep (It's ok. Half of us
didn't either.) all reach into a pocket for one
last idea. The goodbye is when we dig deep
into conversation. So you are not really leaving,
you are staying while leaving, which is of course

zakhor, our collective memory,
tapping you on the collarbone reminding
us that every dinner, candle, word, becomes past
as soon as we eat, light, say it.
Which is to say we are remembering as we depart,
keeping alive that which has slipped away.

This is how we say goodbye—
words, warm food, coat bundled
around the infant of this gathering.
Which is to say perhaps you could stay
a bit longer? Or at the very least,
take something with you.

Tell Me How You Got Here

African Gray Parrot Returns to Owners After Decade
—Telegraph UK

I was not the first to call you
mine. You came to us
British, with only three words:
blimey, matey, persimmon—
all from your original owners, thieves
and animal smugglers, tough accents
mimicked so when you cooed *blimey*
you appeared the pirate ship
version of yourself. And persimmon?
Who knows how animals learn
anything, not least about fruit
we could not afford, searched out
at the market, found slippery piles
at DeMarco's but bought cheaper
grapes instead. Perhaps you'd once lived
with green grocers? At night we guessed
your previous lives, your unknown age,
brushed your beak with a new toothbrush
as you pecked at the packaging. *Matey. Matey.*
Blimey! Your morning greeting,
followed by *persimmon, persimmon,*
persimmon, persimmon—four times each day
for four years until that August,
quiet as milk, heat shafting into our kitchen.
No words from you, only discarded
feathers, a split grape, as though
you'd bolted and left everything.
We left the feathers and grape in place

the way parents who lose children
keep their rooms intact. Just in case. What if.
But nothing. Each morning, listening:
Matey, blimey, persimmon. Those gaping
words a lullaby or prayer. And then—
ten years. We moved on. Bought a beast
of a dog, head big as a toaster oven, solid,
slack-mouthed, but quiet. No words from him. Not
even when, on the fire escape, you appeared—
talons around the railing, head cocked.
Oh, disbelief. How? But the ankle band
(the Brits had done it) was proof.
Here, a grape. Here, a persimmon
we could now afford. Silence from you.
No London accent. *Blimey!* I tried,
brushed your beak, rested my hand
on the dog's head, my mouth open
in encouragement. *Matey? Persimmon,
you remember? Persimmon?*
Your eyes were bright as buttons.
Hola. Hola. ¿Que hora es?
Our parrot returned to us
speaking Spanish, we told the vet.
What if your love returns yet
flaunts its adventures right there—
singing, strutting to Boléro. What
had we missed? *Caqui,* you sang, *Caqui.*
Just what did he want? To be
recognized even though our language
was gone? What had he witnessed
beyond our kitchen? Caqui? Who is Caqui?
And did the bird miss Caqui? I asked
my husband, What if we are not enough?

But he came back. How fun could the outside
world have been if he came back?
What if he's back by accident? I asked.
My husband offered, What if
he never meant to leave? I offered
grapes, called out *Matey*, again, just to see
if you remembered. Brushed your beak. *Caqui.*
I could see your new lives in your
silver-eyed face. This is consolation,
someone coming home to you.
Caqui caqui caqui, you said, so I joined,
both of us cooing aloud. Then I looked it up,
needed to know. *Caqui.* You left,
returned, feathers dropped,
replaced with the same feathers—
changed or not. Engulfed, summoned
by the world. Caqui is *persimmon* in Spanish.
Tell me how you got here.
Tell me how long you will stay.

Acknowledgments

Grateful acknowledgment is made to the following journals in which some of the poems in this collection first appeared.

Blackbird: "April in Wiltshire," "Japan, Autumn"
The Chattahoochee Review: "3-Body Problem"
Cimarron Review: "As My Children Outgrow Our House,
 I Consider Household Goods"
The Cincinnati Review: "Epigenetic Inheritance"
Hart House Review: "Biology on Goodhope Bay"
Jet Fuel Review: "My 8-Year-Old"
The Journal: "Flânerie"
Lunch Ticket: "Moorings," "Walking the Dog in Autumn, I Stop
 to Tie My Shoe"
The Maine Review: "Grandfather Reappears"
Martin Lake Journal: "The Firefly"
The Matador Review: "Passover in Jamaica"
Mississippi Review: "The One Item"
Motherwell: "Flowers in Odd Numbers"
New Ohio Review: "A Cure for Grief"
North Dakota Quarterly: "On Spotting Stray Shoes," "Standing in
 the Kitchen with My Mother"
Passages North: "The Passover Table"
Painted Bride Quarterly: "Thoughts Upon Hearing"
Qu Literary Journal: "Mark Twain's Ghost"
The Rumpus: "What can I tell you"
Shenandoah: "Seventeen Ways of Looking at a Crime," "Tell Me
 How You Got Here"

Tar River Poetry: "Notes to Self"

"Japan, Autumn" received the Alpine Fellowship Prize, Venice Symposium, 2017.

About the Author

Emily Franklin is the author of a novel, *Liner Notes*, and a short story collection, *The Girls' Almanac*, more than sixteen novels for Young Adults, and a cookbook/memoir. Her work has been published in *The New York Times* and *The Boston Globe* and in such journals as *The Cincinnati Review, Shenandoah*, and *New Ohio Review*. Her work has been long-listed for the London Sunday Times Short Story Award, featured and read aloud on National Public Radio, and named notable by the Association of Jewish Libraries. She has a BA in writing from Sarah Lawrence College and an MA from Dartmouth College. She lives in Massachusetts. *Tell Me How You Got Here* is her debut poetry collection.

www.emilyfranklin.com

CPSIA information can be obtained
at www.ICGtesting.com
Printed in the USA
JSHW022323230123
36649JS00002B/95

9 781947 896338